What is Zentangle?

Zentangle is meditation achieved through pattern-making. A Zentangle is a complicated looking drawing that is built one line at a time. Simple tangles, or patterns, are combined in an unplanned way that grows and changes in amazing directions. With your mind engaged in drawing, your body relaxes. Anxiety and stress move to the back burner. Often, new insights are uncovered along with a sense of confidence in your creative abilities.

Zentangle was developed by artists Rick Roberts and Maria Thomas as a tool to be used by artists and non-artists alike. For information about the process, instructions, and lots of beautiful examples, be sure to visit their website at *www.zentangle.com*

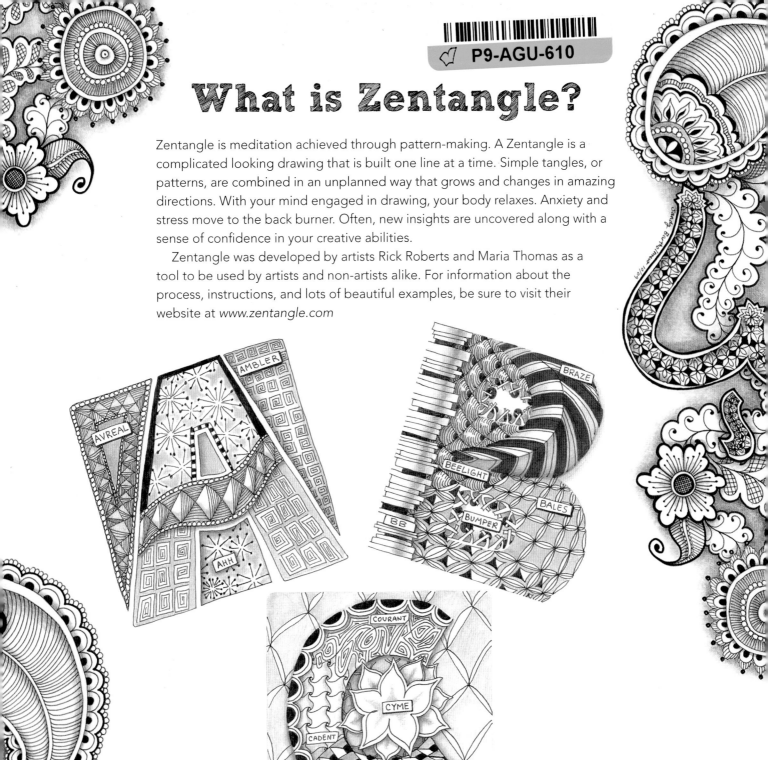

978-1-4972-0110-1

© 2016 by Sandy Steen Bartholomew and New Design Originals Corporation, *www.d-originals.com*, an imprint of Fox Chapel Publishing, 800-457-9112, 1970 Broad Street, East Petersburg, PA 17520.

New gallery art and text on pages 7–16 © New Design Originals Corporation and DO Magazine, *www.domagazines.com*.

Printed in the United States of America
First printing

Tools:
All You Really Need

To complete any Zentangle creation, you only need three tools: a pencil, a pen, and a piece of paper. While you can use any type of pencil, pen, or paper you desire, those listed are recommended specifically for the Zentangle method. While you only need the essentials to get started, there are lots of extras you can consider to enhance your Zentangle art.

Pencil. Any No. 2 pencil will do. Find one without an eraser so you won't be tempted to "fix" your art.

Pigma® Micron 01 black pen. With pigmented, non-bleeding, archival ink, these 0.25mm pens are a dream for drawing.

Zentangle tiles. These 3½" (89mm)-square tiles are made from fine Italian paper. Once you tangle on these, you'll never be happy with cardstock (or notepaper!) again (visit *www.zentangle.com* to purchase tiles). Watercolor hp paper can make a nice surface to tangle on, too, but be sure to cut it down to a manageable and portable size.

Storage box. A simple box with a lid will keep your tools and tiles safe in your purse or pocket. A little cardboard jewelry box is a perfect option.

Pencil sharpener. No explanation needed here. If you want, purchase an electric one for your home and a small handheld one for tangling on the road.

Graphic 1 pen. These pens have the same ink as Micron pens, but with a bullet-shaped tip that's great for making wide lines and filling in large areas of your Zentangle tile with black.

Pigma® Micron 01 pens in colors. A red Micron pen is perfect for use on trading cards or any time you want to show Zentangle steps. A brown or sepia Micron pen works beautifully for Mehndi designs and on brown paper, too.

White colored pencil. This is great for getting a Zentangle piece started on dark paper.

White gel pen. This allows you to create beautiful Zentangle art on black paper.

Blending stumps. Use these to smudge your pencil lines when shading a Zentangle piece. You could use your finger, but these are neater, more precise, and come in different varieties, sizes, and shapes.

Tangle ATCs (Artist Trading Cards). These blank trading cards are a way to keep track of tangles. They are the size of baseball cards and fit into the collector sleeves that go into a three-ring binder. These are perfect for keeping patterns organized, and they make preparing for a class or Zentangle club meeting a breeze. A journal or notebook works well, too.

The Basic Steps

1. Dots

2. String

3. Tangles

4. Shade

5. Initials

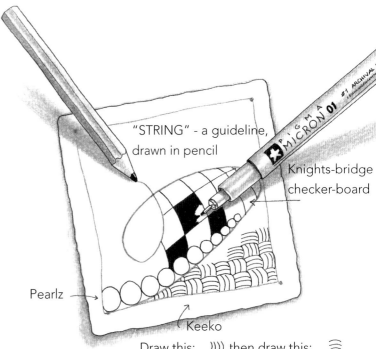

"STRING" - a guideline, drawn in pencil

Knights-bridge checker-board

Pearlz

Keeko

Draw this:)))) then draw this: ≋

Dots. Using your pencil, make a dot in each corner of the tile. Connect the dots to form a border.

String. Draw the String.

Tangles. Switch to your pen and fill each section of the String with Tangles. Try the ones on the next page. Be sure to turn your tile as you draw. There is no right-side-up in Zentangle. Allow yourself to be surprised by what appears.

Shading. Use your pencil to add shading and depth. Smudge with your finger or a paper stump. It's fine if you prefer not to shade your Zentangle pieces. Most of the tangles look great either way.

Initial. As the final step, put your initials on the front of the tile, and sign and date the back. There is no top or bottom to a Zentangle piece, so the initials can go anywhere.

ZENTANGLE LINGO

Tangle. A pattern taken from fashion, art, nature, observation, history…anywhere!

Zentangle. The method of using pattern drawing to focus the mind. Also, the finished artwork.

CZT. A Certified Zentangle Teacher who has been intensely trained by Rick Roberts and Maria Thomas.

Tip: "Zentangle" is a noun, not a verb. Don't say: "I Zentangled my bathroom floor." Say: "I tangled my bathroom floor." Other things to say: "I need to create a Zentangle, right now!" And: "Sorry, I didn't hear you. I was busy tangling."

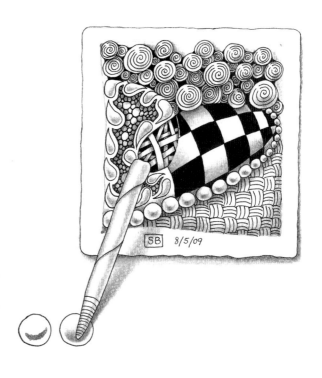

SB 8/5/09

Try These Tangles

There are lots of tangles out there, and new ones are being created all the time. If you'd like to learn the steps for some other tangles, check out online resources like *tanglepatterns.com* or books like *Zentangle Basics* and *Joy of Zentangle.*

Jute

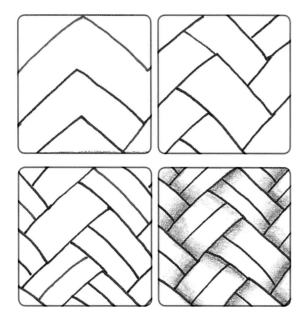

TIP

Notice how tangles are built backwards. Each addition is drawn *behind* the previous one to give the illusion of depth.

Ripple

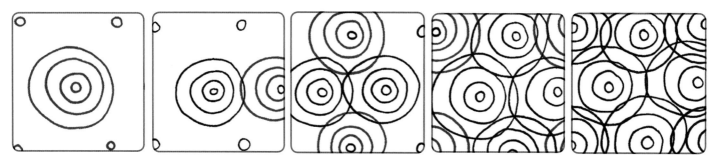

Sabi

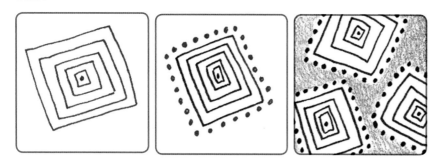

Shading

Shading adds so much to Zentangle art. Compare the two fish ZIAs (Zentangle-Inspired Art) below. Shading can make objects pop from the page, hide errors (pen slips, smears, etc.), and tone down an overly busy background. You can use shading to add color, contrast, depth, and roundness to a Zentangle or ZIA.

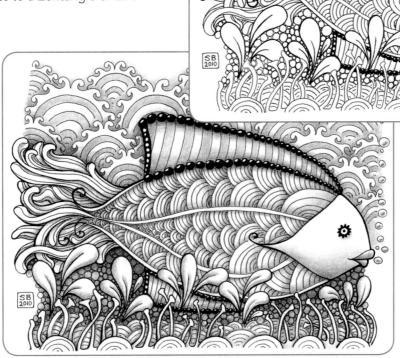

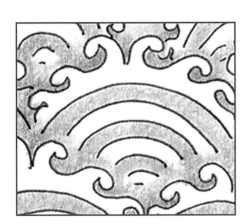

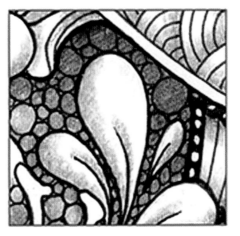

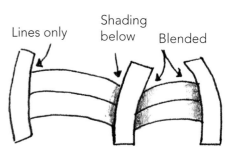

Lines only Shading below Blended

Color. The simplest shading just adds a third color to the basic black and white of a Zentangle piece. Try gray in spots where you would normally use solid black or white. It will add interest to dots, checks, stripes, and more.

Contrast. A light object against a dark background will be highlighted and pop forward. Dark against light will recede, or look like a hole in the surface. Using gray shading adds a middle ground. In this Zentangle piece, it makes the busy bubbles recede and the plants pop up.

Depth. To make something look like it is going under another object, add a little shadow on either side of the upper object. Notice how the blending gradation actually makes the pattern above looked curved.

Flat Shading

Layers. Add a bit of shadow under the bottom edges of objects. A crisp shadow makes it look like the objects are close to the surface.

Cutouts. A smudged shadow lifts an object higher off the surface.

Overlap. Add just a little shading on either side of the upper object.

Ground. A smudge of shadow at the base of an object suggests a floor.

Cubed. For cubes, shade one very dark side, one light gray side, and one side stays white.

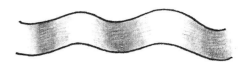

Shine. Shade the tangle so it's light on the "hills" and dark in the "valleys."

Round Shading

Pearl. Use a "smiley face," or crescent, of shading. Smudge in a circle.

Puffed. Smudge shadow along the bottom edge.

Gradation. Shade the bottom edge, and then blend upward.

Pressed. Shade the top edge; smudge downward.

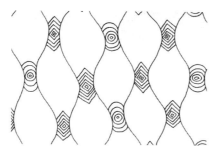

Really flat and boring.

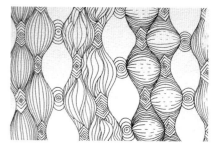

Roundness created by lines only.

A Note from the Publisher
We're hearing more and more from readers who want to add color to their art (Zentangle and otherwise) and who are looking for ideas to take their pieces beyond the printed page. These designs and ideas are courtesy of the editors of DO Magazine, *www.domagazines.com*.

Idea Gallery

It is so much fun to tangle and color the designs in this book, but sometimes a piece of art you have created inspires another piece of art! If you are inspired by one of these coloring pages, don't be afraid to take it out of the book! Frame your art, decoupage it onto another item, or use it to make a cute card. These letters lend themselves to personalized art, which is extra special to give as a gift or display in your home. Here are some ideas to spark your creativity. There are so many things you can make!

Mixed media art. Your art will start out as a colored design on paper, but there are lots of places it can go from there. Try embellishing one of your colored designs with gems or glitter for a unique mixed media project that has some sparkle.

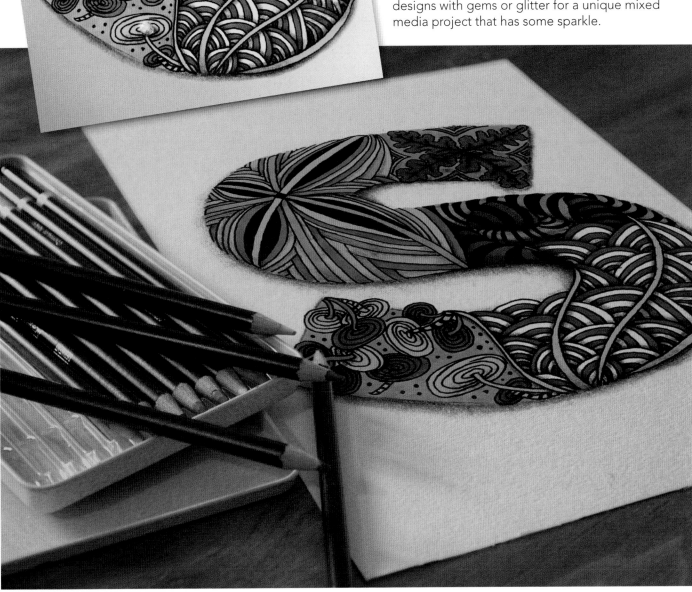

Cute Crafts

Your coloring designs can be used to make loads of personalized crafts.

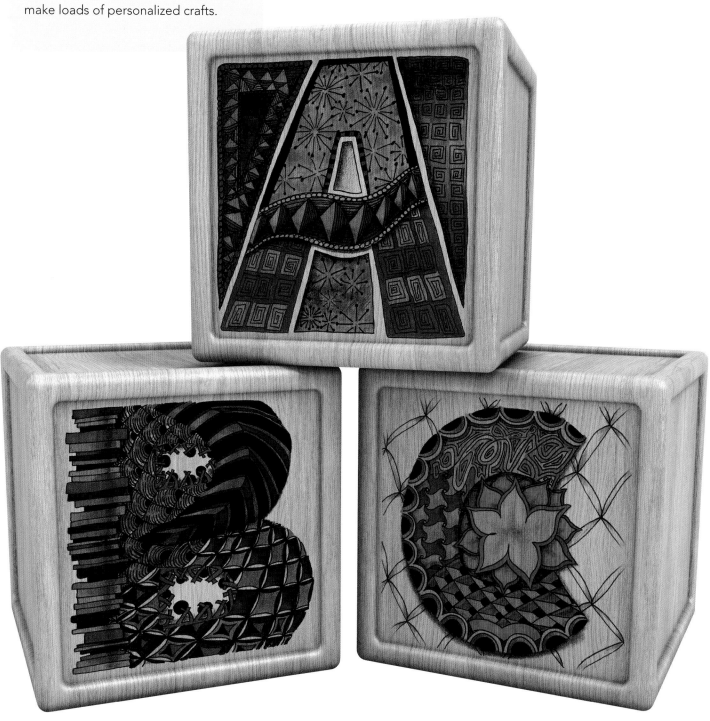

Decoupage blocks. Decoupage your colored letters onto wooden blocks. You can make a whole alphabet or just a name or favorite word. You could even use the blocks for another craft, like an ornament. For something extra special, decoupage your initial (or family's initial) on two opposing sides of the block. Then, decoupage family photos on the remaining sides.

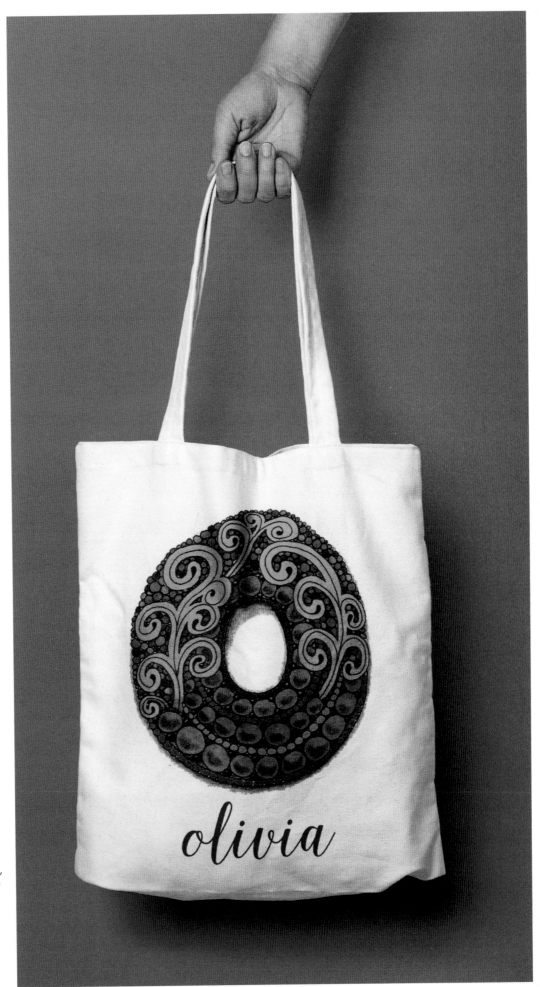

Personalized tote. Use a fabric transfer technique to put your personal stamp on a tote or backpack. You can add additional embellishments with stamps, permanent markers, or puffy paint. You could tangle the whole fabric surface if you wanted to! Add your full name or a favorite word or saying.

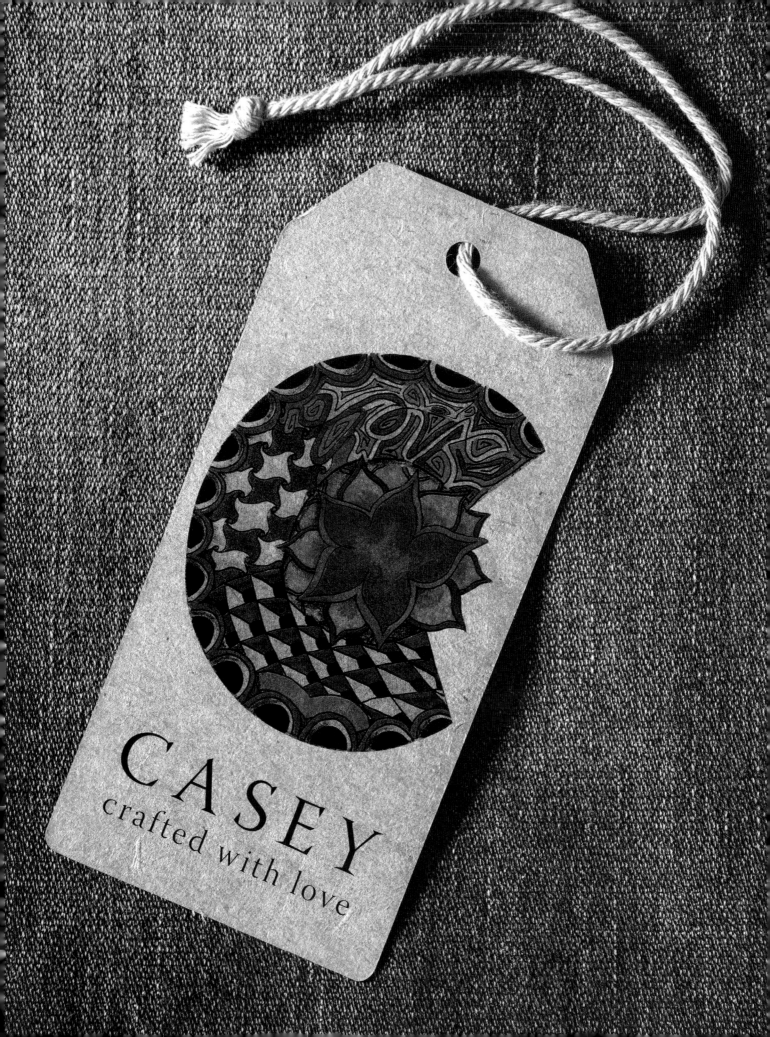

Personalized Cards and Tags

It's so nice to add a personal touch when giving a gift, and letters are the perfect way to do it. Your recipient will appreciate the extra effort you took to make a memorable card or tag.

<Personalized gift tag.
Add a special touch to a gift or party favor with a personalized gift tag. You can use your own name or the recipient's. Have fun experimenting with different types of cards and string. This design has a rustic feel, but you could create one that's bright and modern or simple and classic.

Crafty card. Give someone a special treat by featuring his or her initial or name on a birthday card. It is definitely not the type of card you will find in the store. If you're feeling ambitious, draw "happy birthday" in outline letters and fill those with tangles, too!

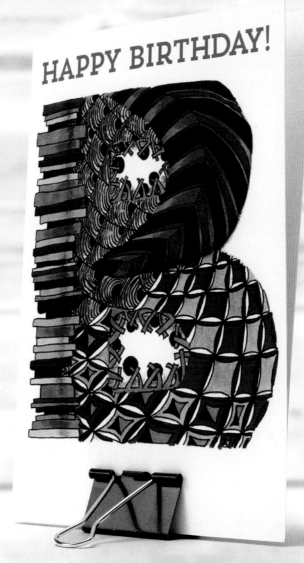

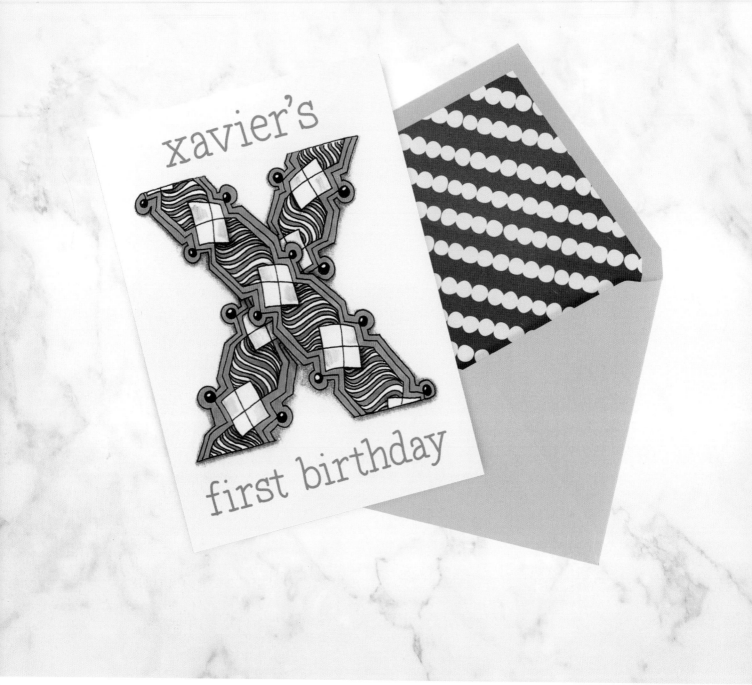

One-of-a-kind invitation. No one will forget about your party if you create a totally unique invitation. This design is super sweet, but you can adapt it for any type of party or event you are hosting.

Be my Valentine.
Valentine's Day is definitely the time to go the extra mile with personal touches. A handcrafted card is a beautiful way to express a Valentine sentiment. You can take it even further by attaching a charm or other special embellishment.

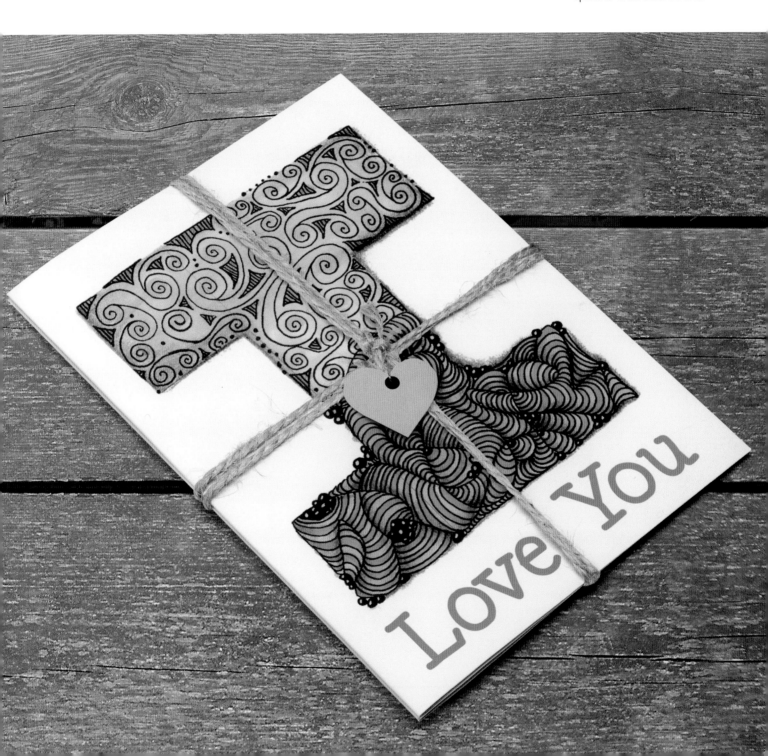

Home Accents

You want the items you display in your home to brighten up your day and have special meaning to you. They should bring a smile to your face and make you feel comfortable and cozy. Using letters is a great way to create personalized or unique home décor pieces that will have special meaning to you.

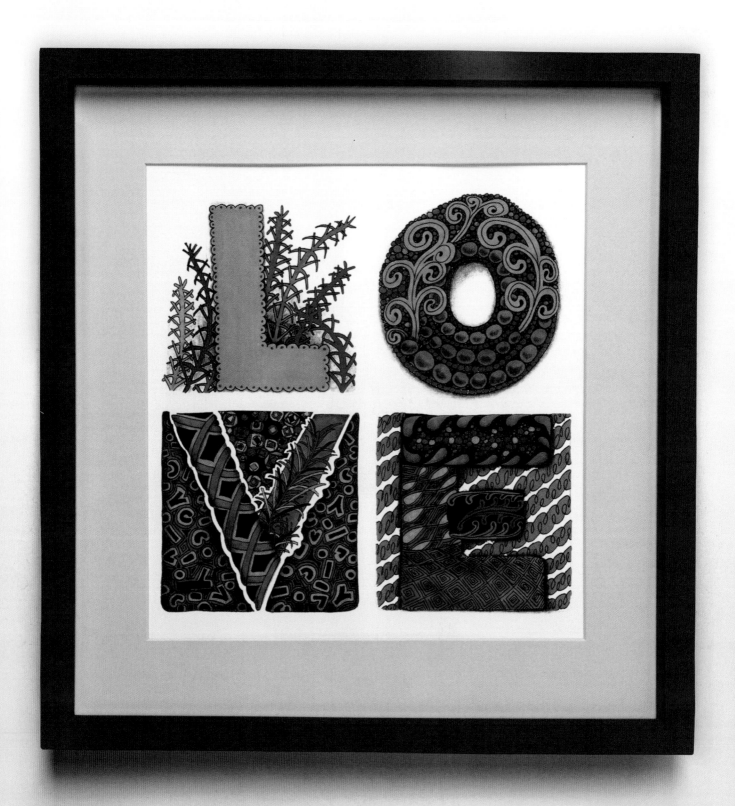

< Framed word art.
Monograms, letters, and word art make wonderful home décor pieces that add a unique, personal touch to any room. Feature your initial, family name, or favorite positive word or message—whatever inspires you and puts a smile on your face when you look at it! Use a unique frame or matting for added interest. You could also use a collage frame or frame each letter in a word separately.

Candleholder. Decoupage a letter onto a glass container to make a unique candleholder. This technique could also be used on a glass vase or lamp. Create a set of candleholders for display on a mantle or coffee table.

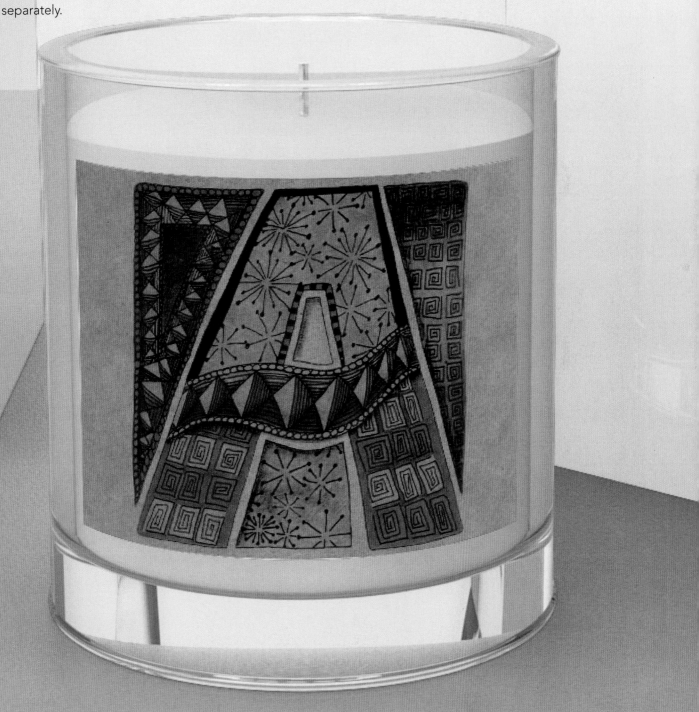

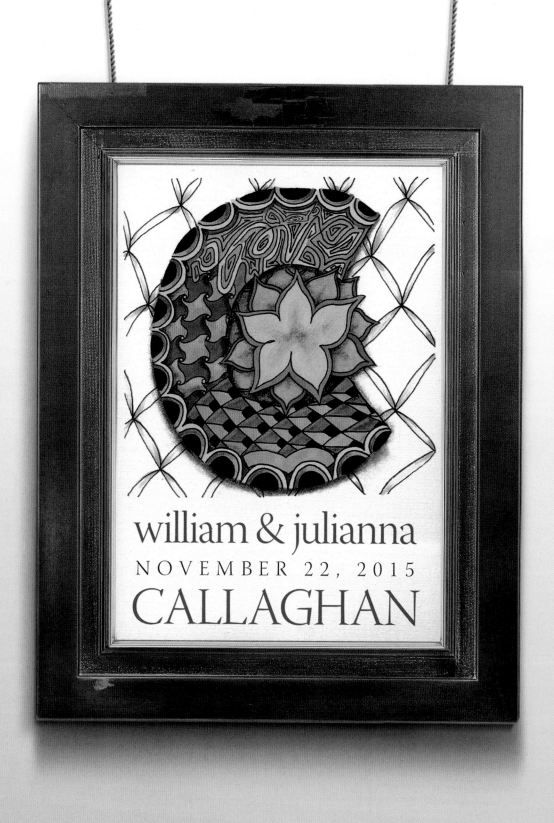

Anniversary frame. Life has lots of special moments, but not many of them trump a wedding day. Give your anniversary date special significance by crafting a unique framed piece featuring your family name. This makes a wonderful gift for newlyweds.

Practice Shading

Get some practice shading by following the prompts below.

Draw a shape, like a circle, and outline it again in pencil. Use your finger or a paper blending stump to smudge the pencil. Blend back and forth and slowly spread the gray away from the circle onto the white paper.

Fill all the sections of a tile with the same tangle. Then, make each one unique by shading it differently than the others.

Tangle Exercise

Leave the top left square empty. Put a basic tangle into each of the top three squares and three tangles you use a lot (or never!) into the three squares along the left edge. Now combine each row and column to create new tangles.

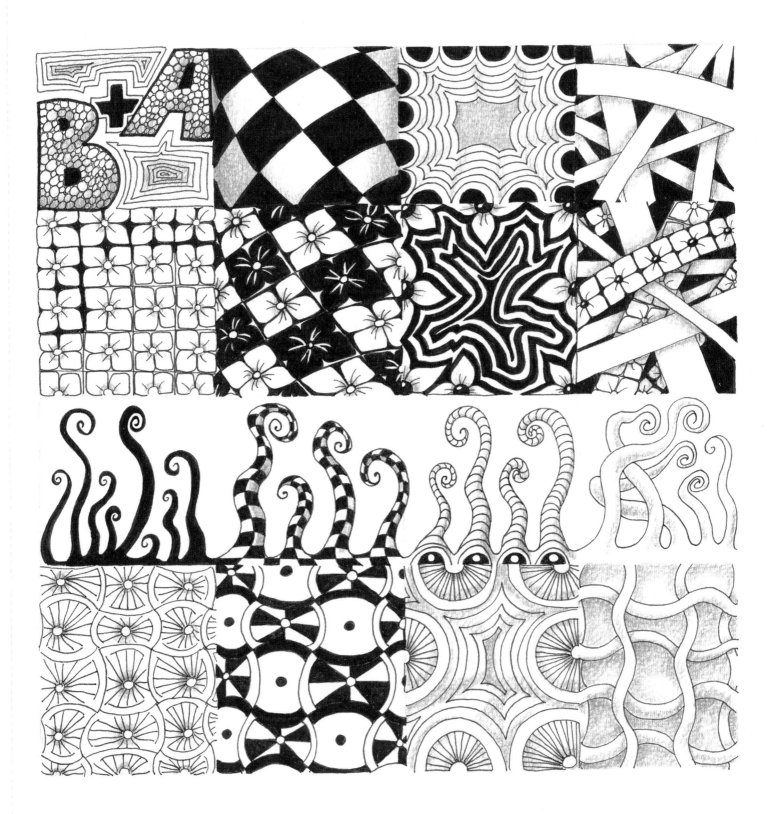

Practice Letters

Try tangling these letters. What happens if you only use one tangle? What happens if you use lots of different tangles? How can you make the same letter look different using shading?

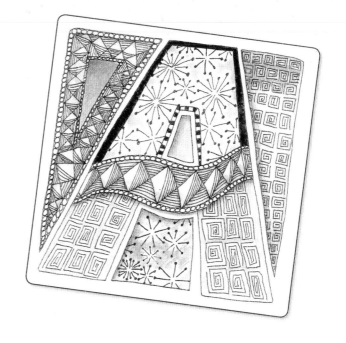

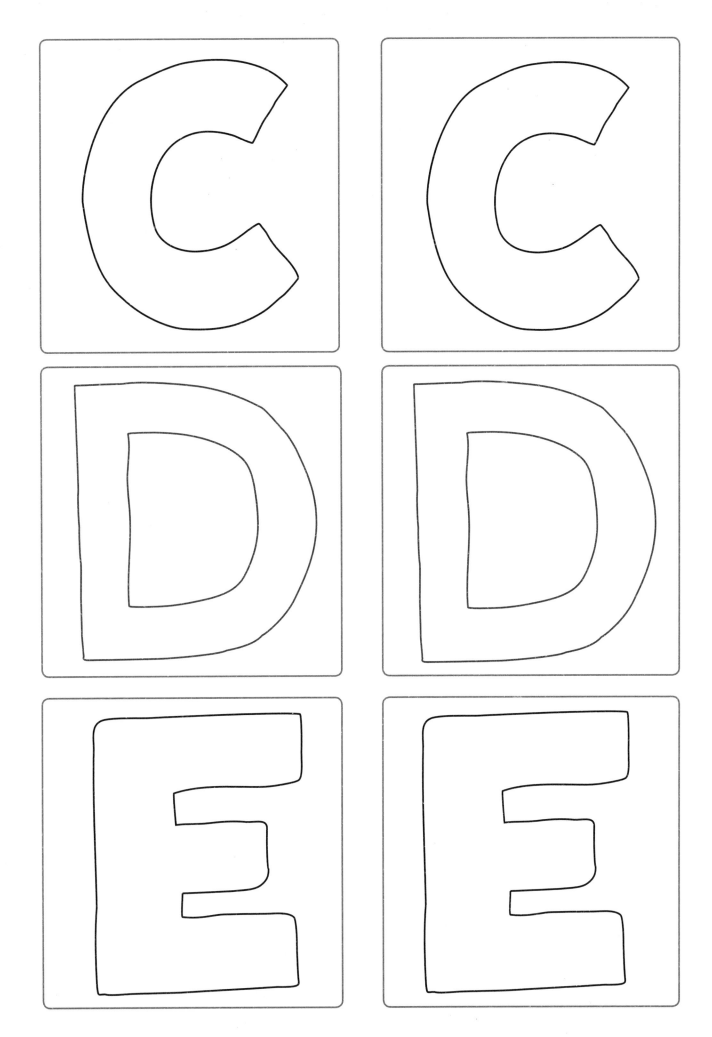

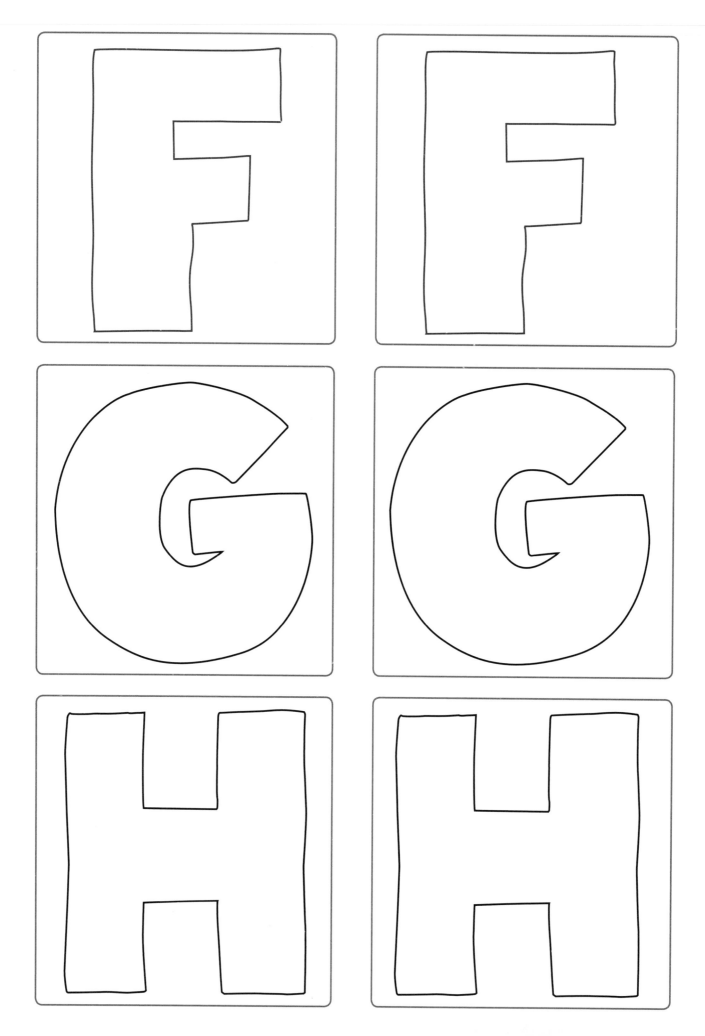

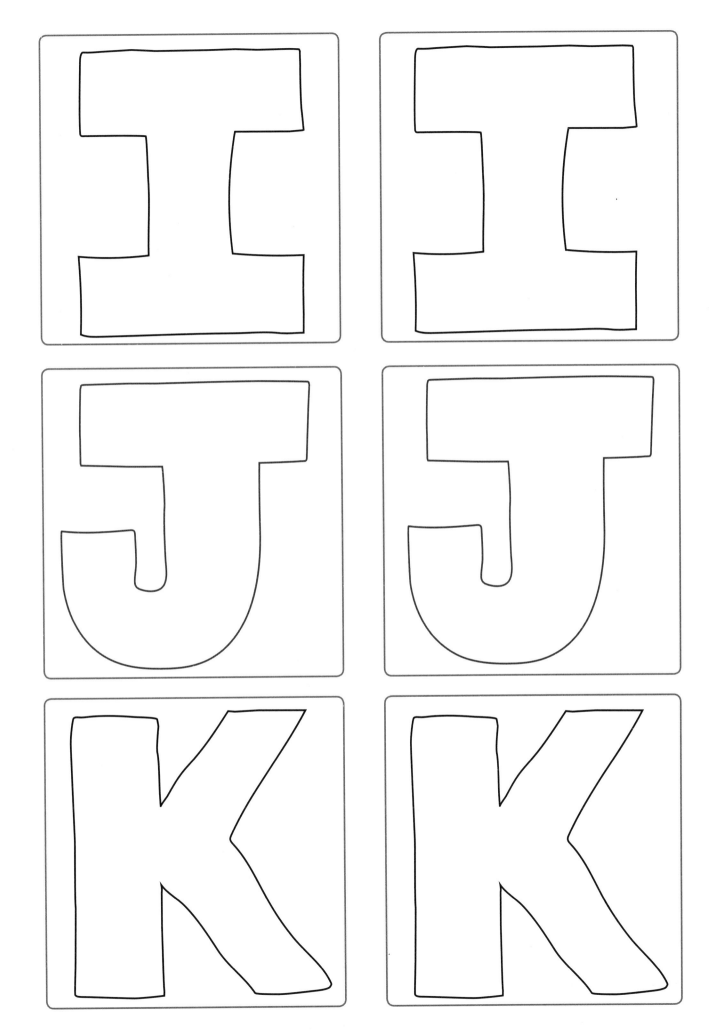

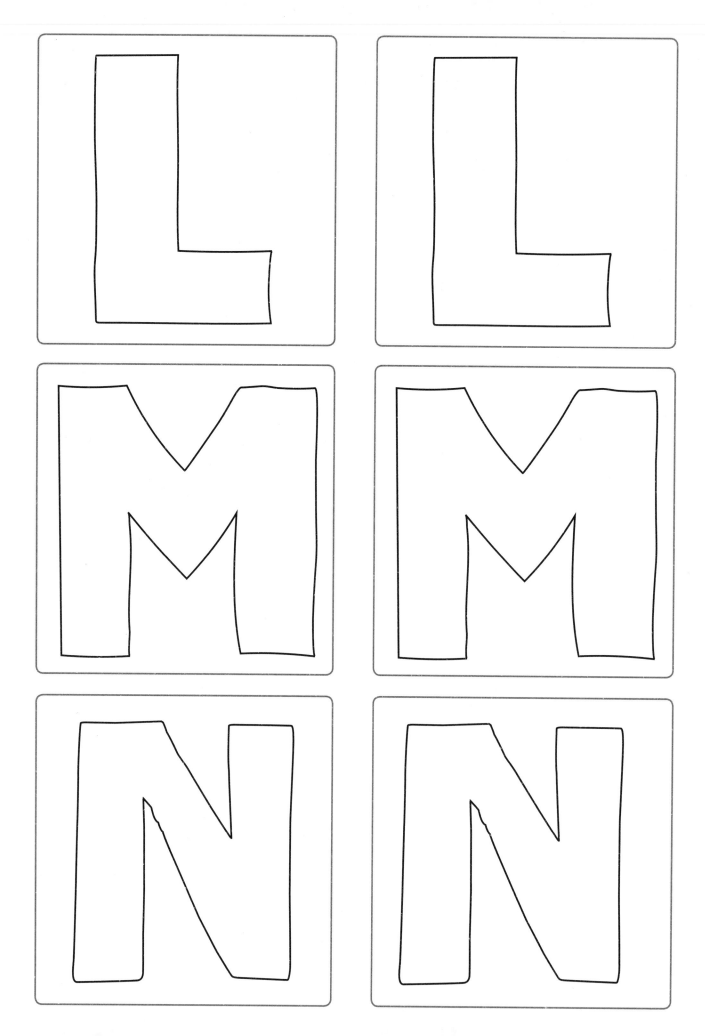

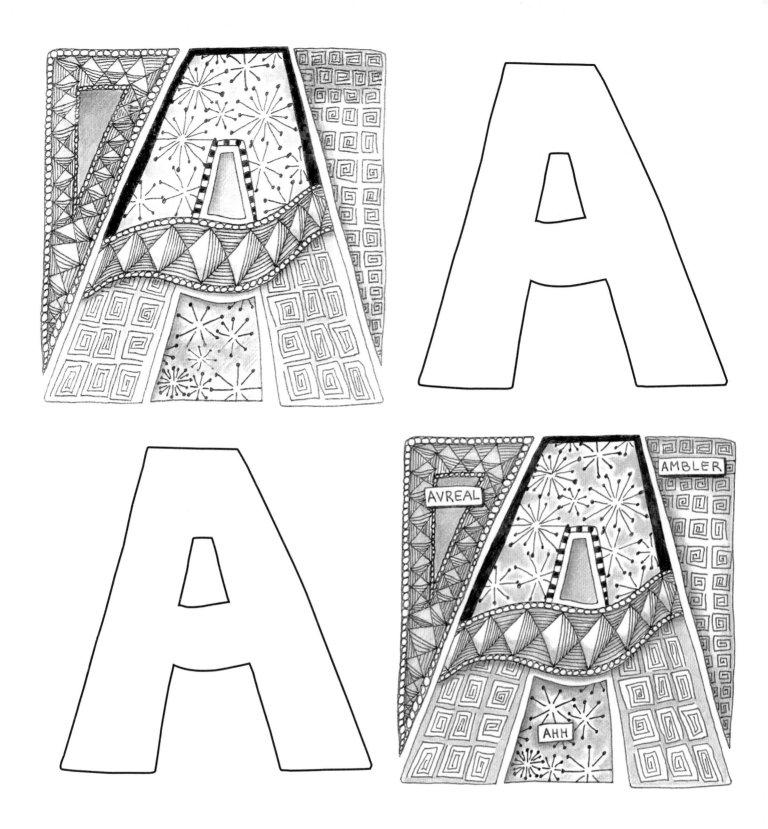

The Letter **A** from **AlphaTangle**

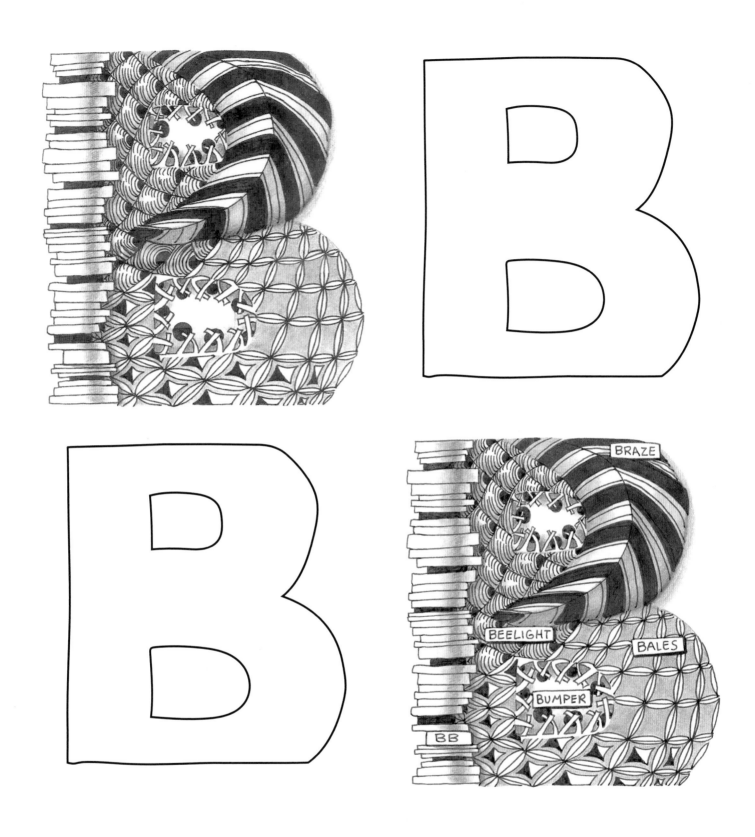

The Letter **B** from **AlphaTangle**

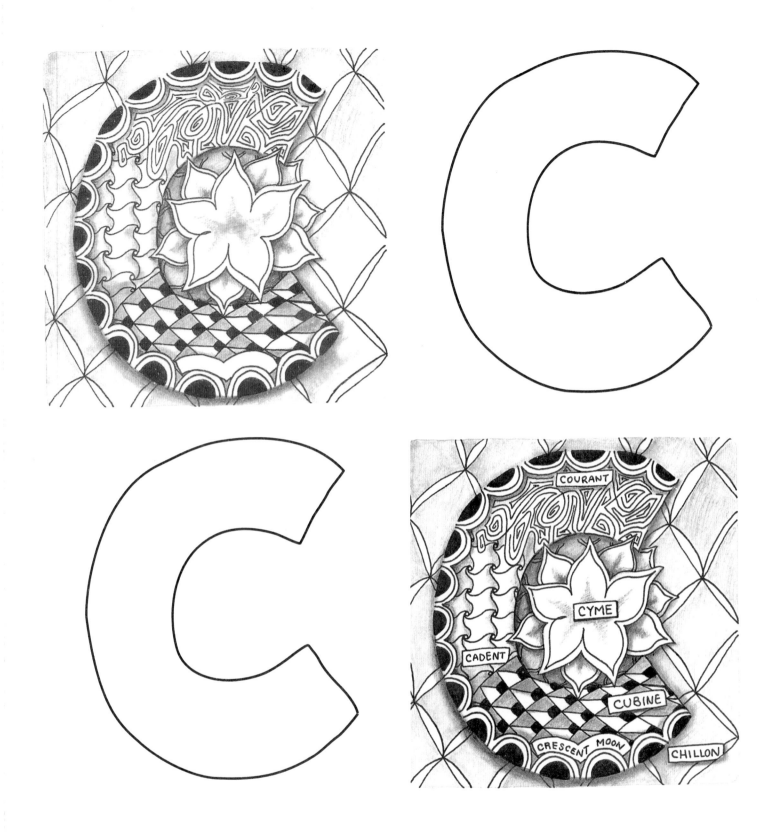

The Letter **C** from **AlphaTangle**

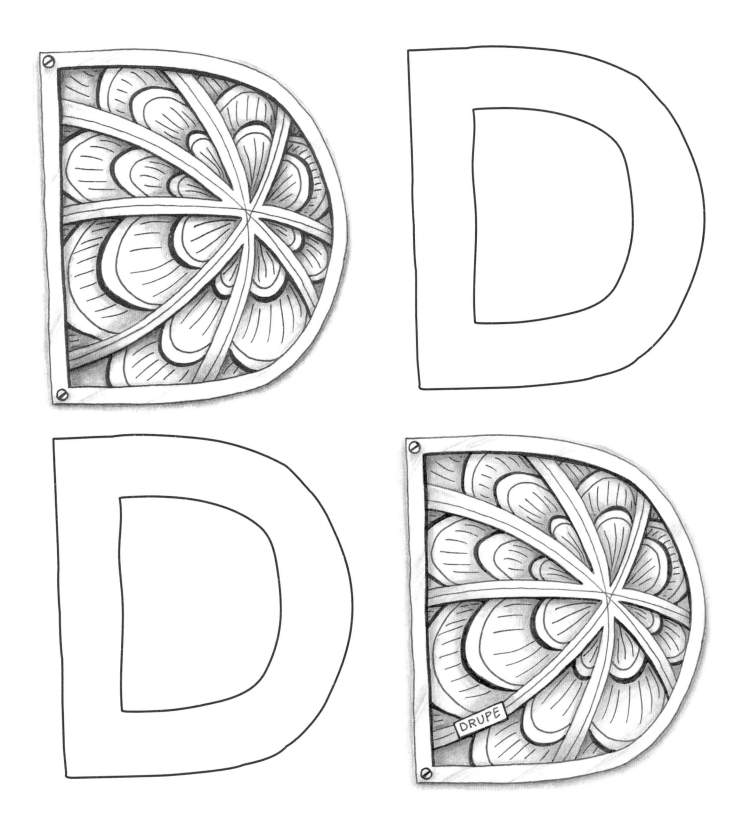

The Letter **D** from **AlphaTangle**

© Sandy Steen Bartholomew, CZT

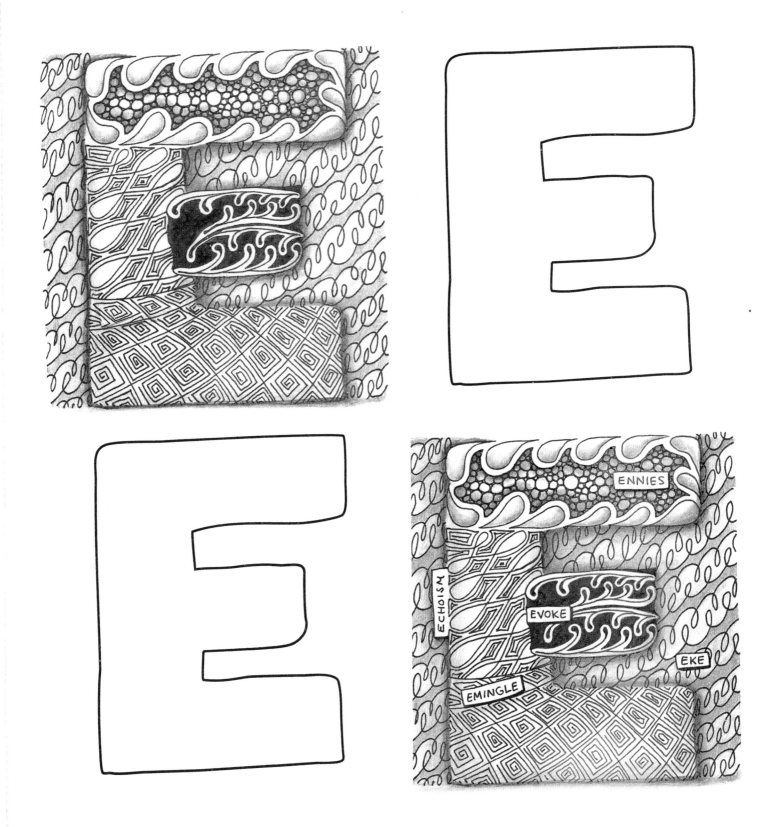

The Letter **E** from **AlphaTangle**

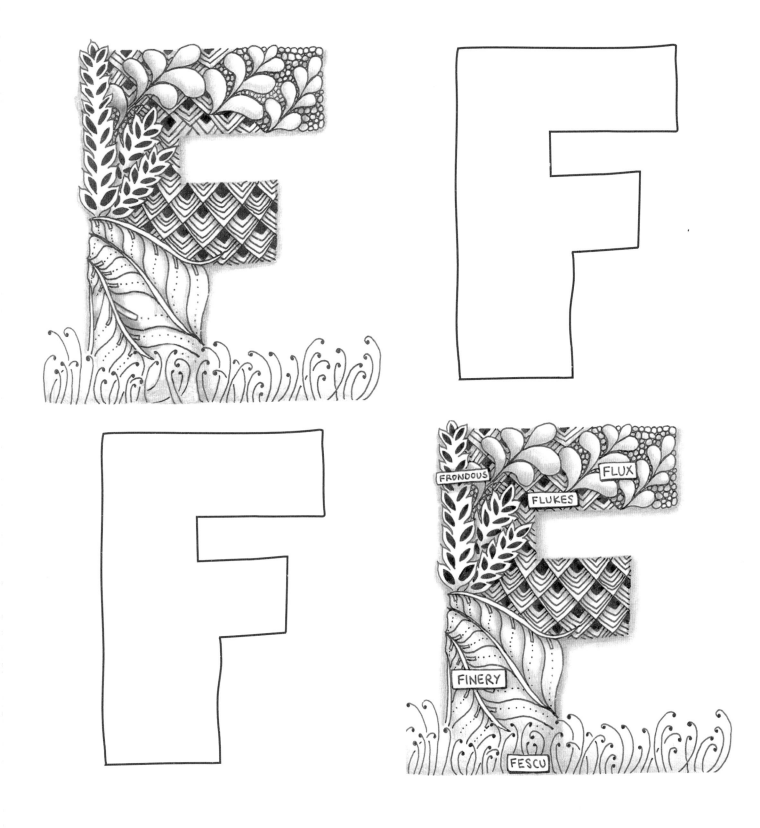

The Letter **F** from **AlphaTangle**

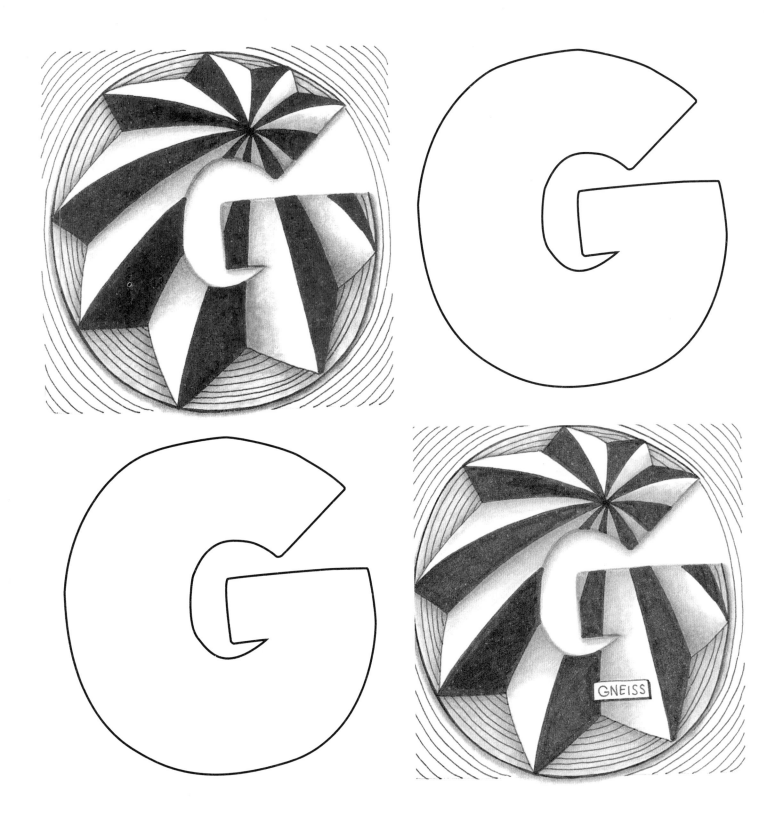

The Letter **G** from **AlphaTangle**

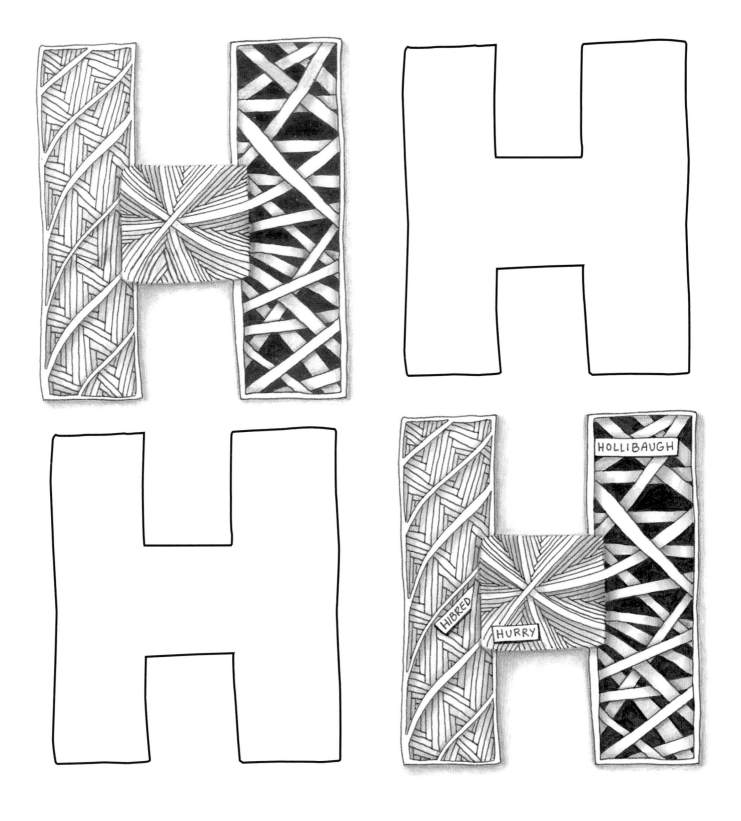

The Letter **H** from **AlphaTangle**

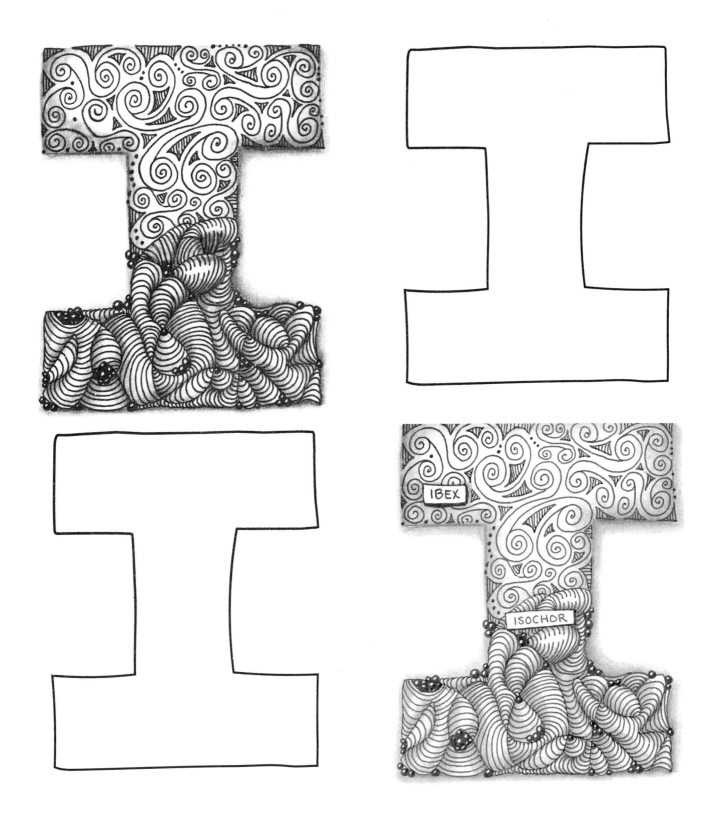

The Letter **I** from **AlphaTangle**

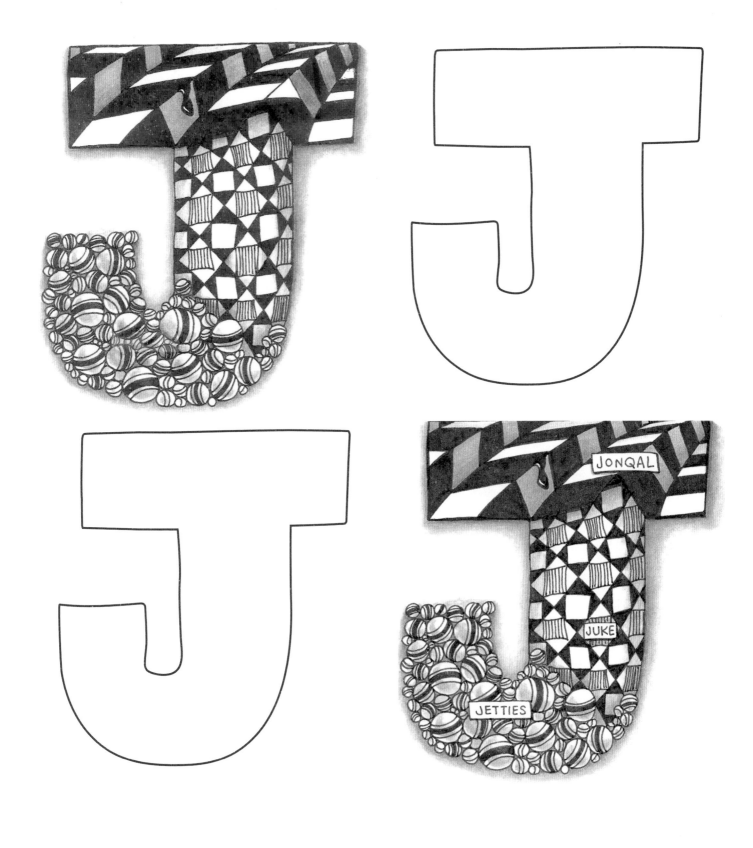

The Letter **J** from **AlphaTangle**

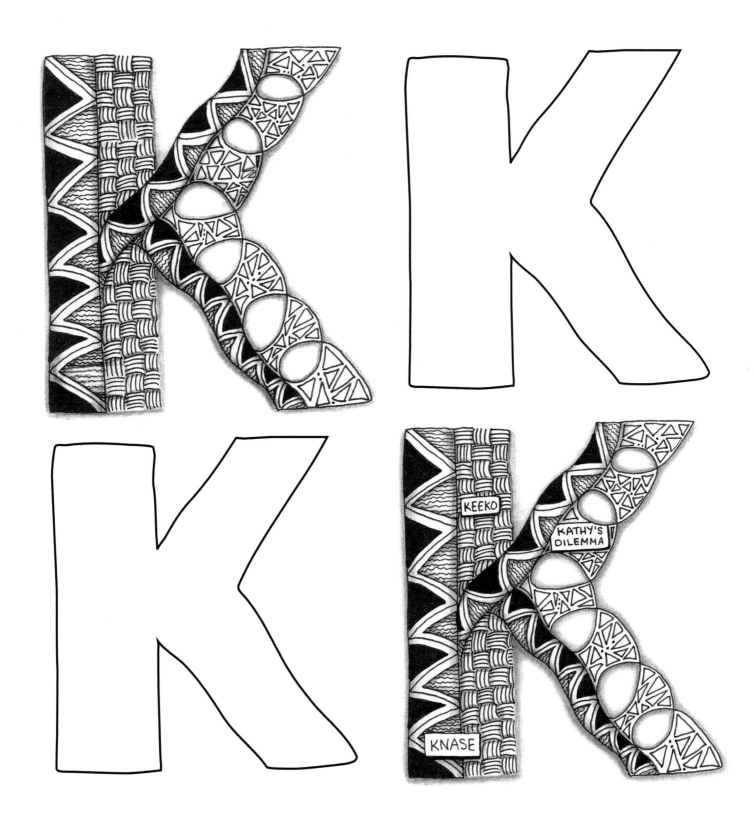

The Letter **K** from **AlphaTangle**

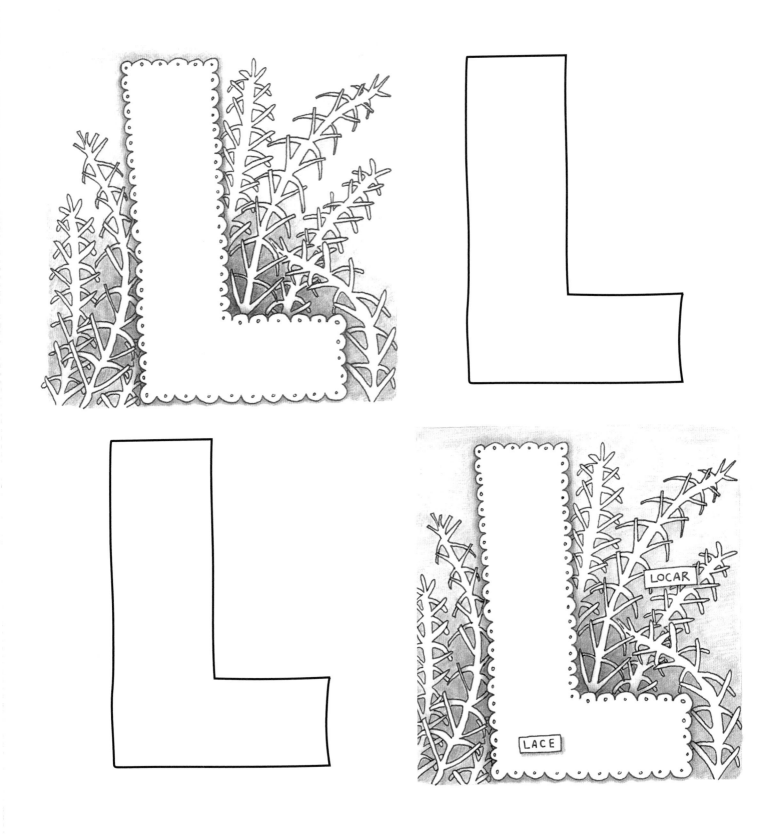

The Letter **L** from **AlphaTangle**

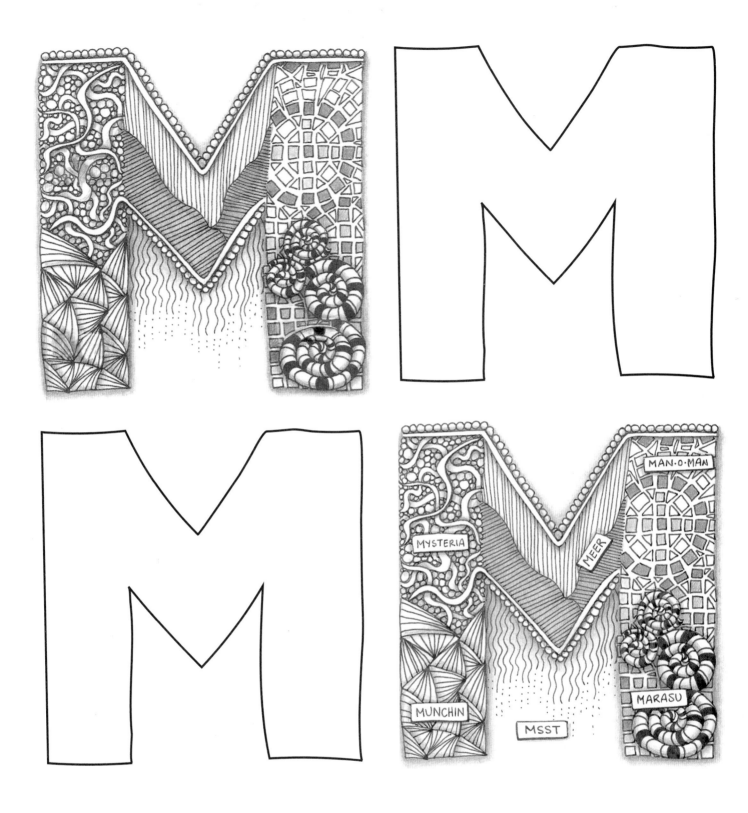

The Letter **M** from **AlphaTangle**

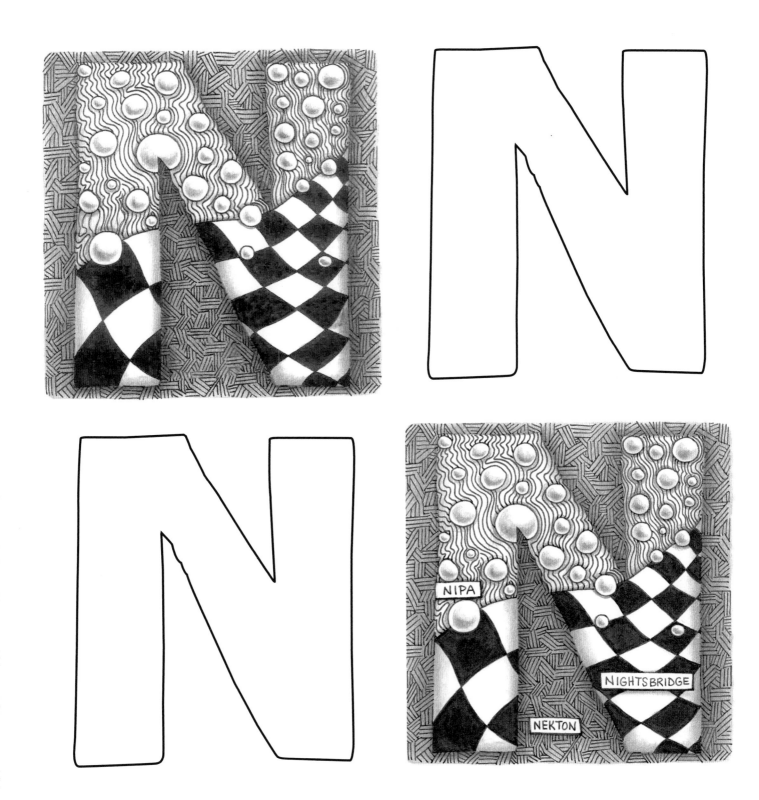

The Letter **N** from **AlphaTangle**

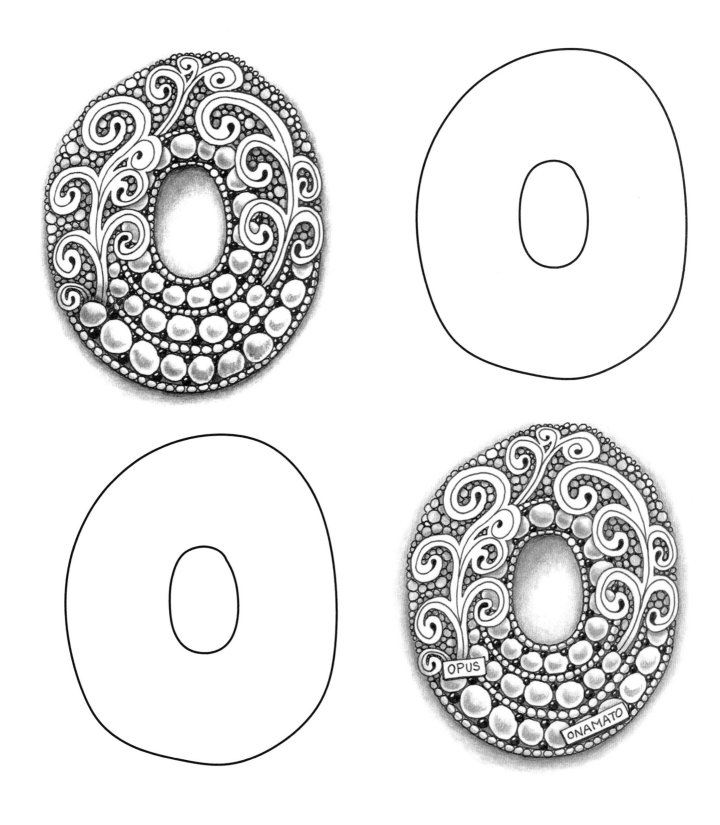

The Letter **O** from **AlphaTangle**

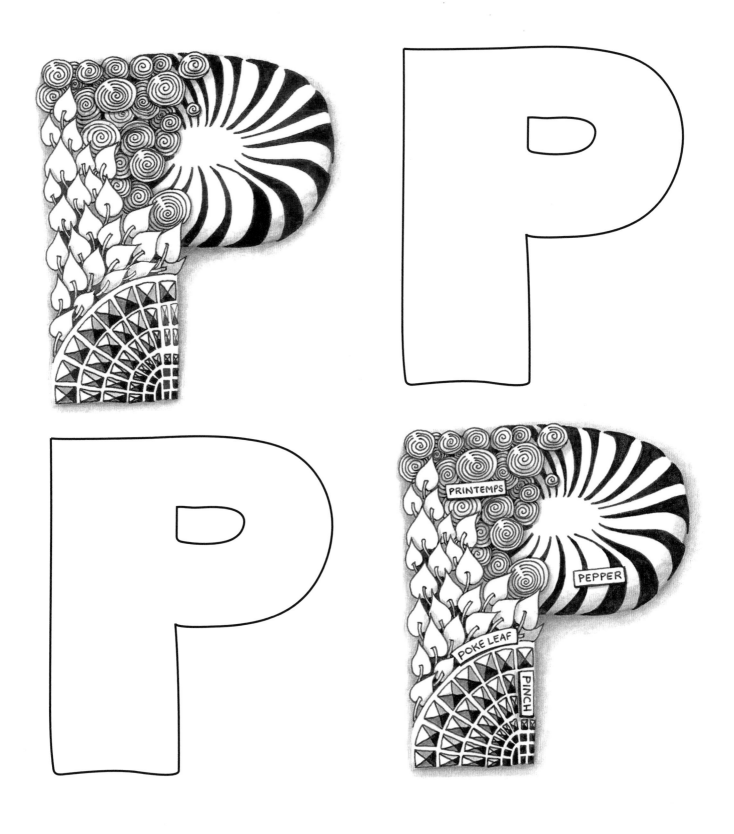

The Letter **P** from **AlphaTangle**

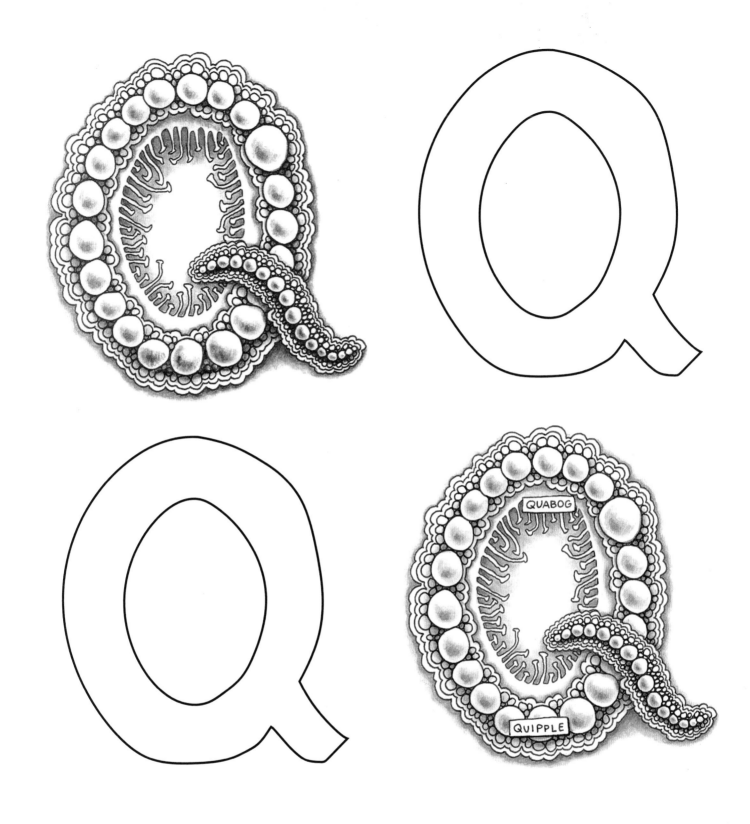

The Letter **Q** from **AlphaTangle**

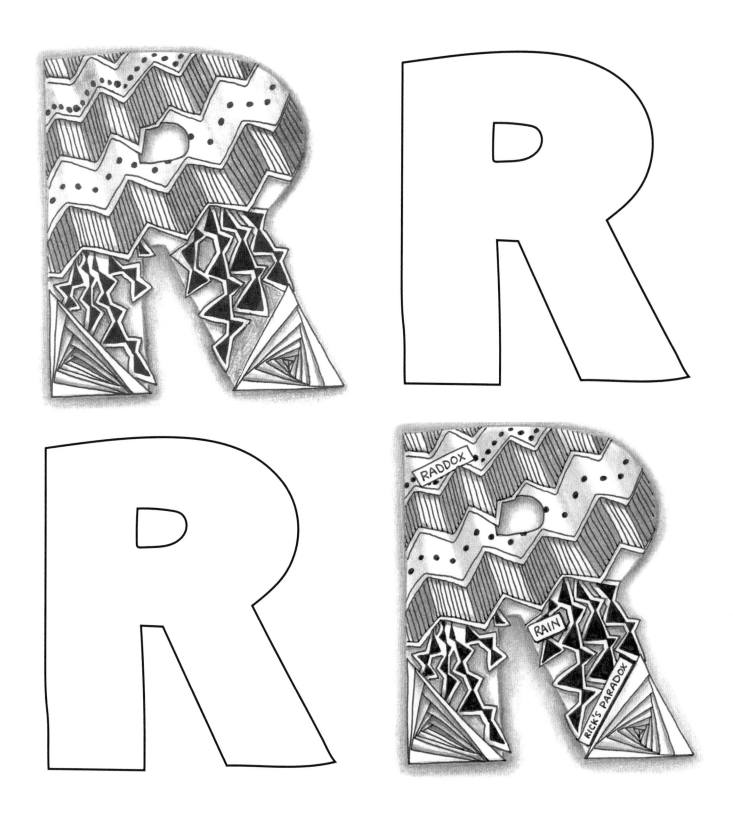

The Letter **R** from **AlphaTangle**

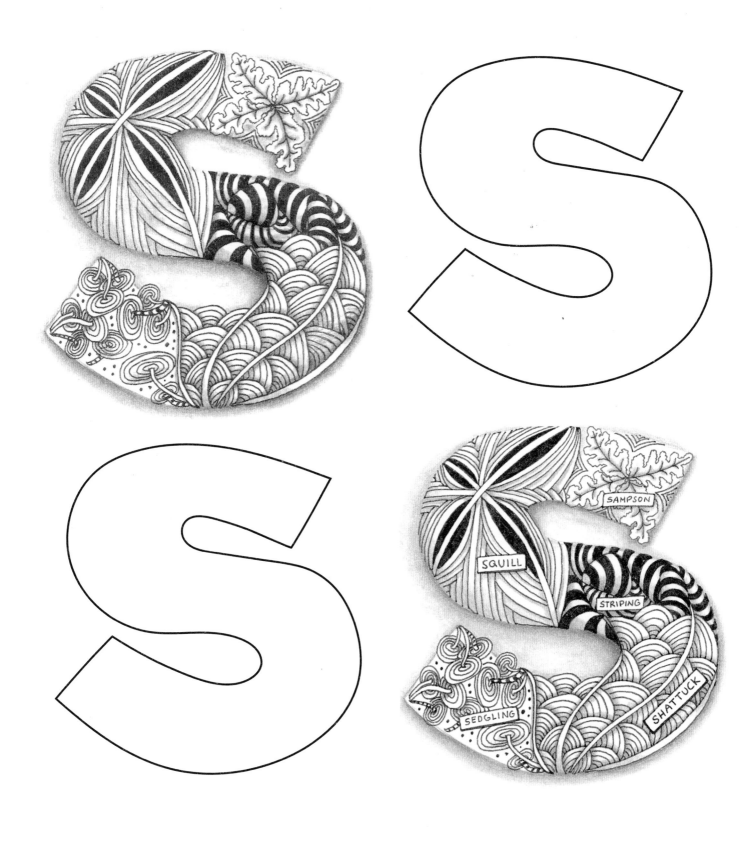

The Letter **S** from **AlphaTangle**

© Sandy Steen Bartholomew, CZT

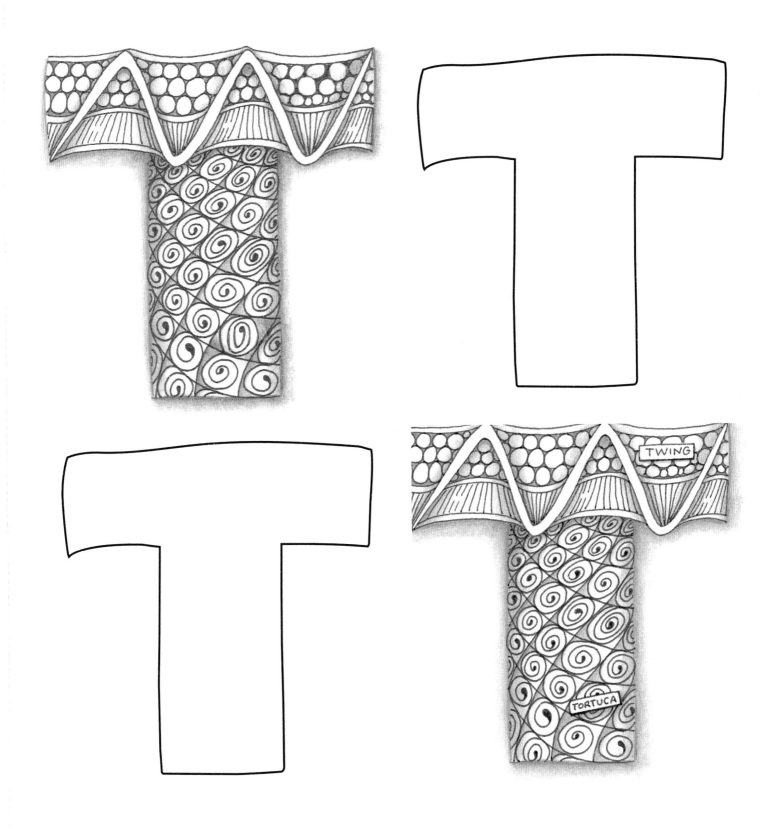

The Letter **T** from **AlphaTangle**

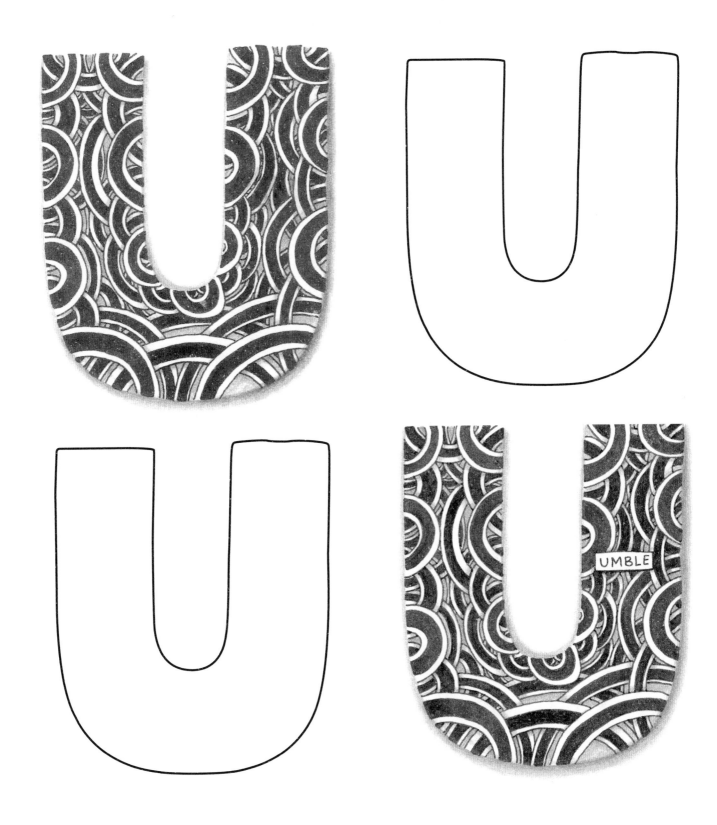

The Letter **U** from **AlphaTangle**

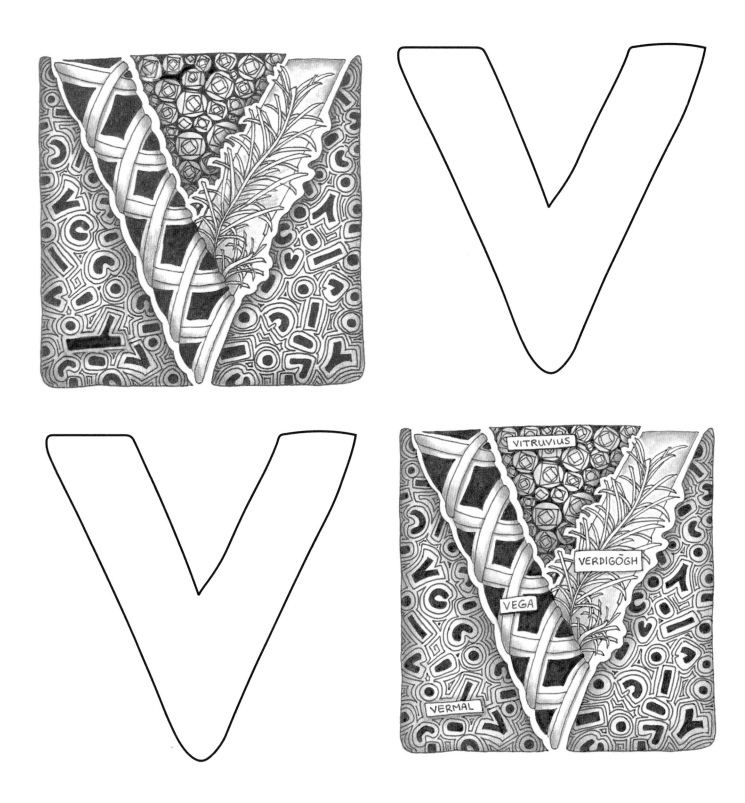

The Letter **V** from **AlphaTangle**

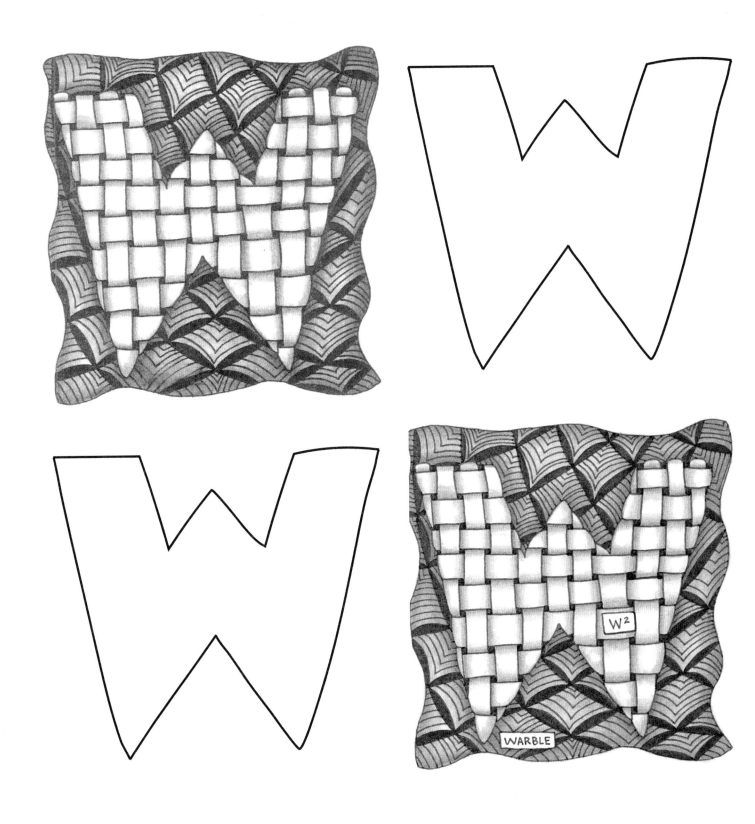

The Letter **W** from **AlphaTangle**

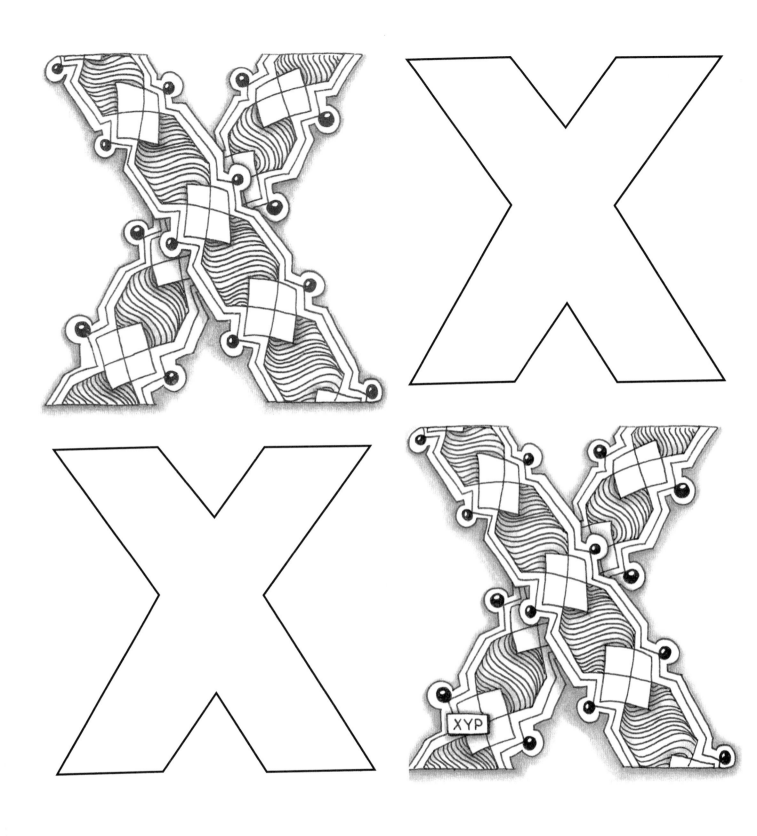

The Letter **X** from **AlphaTangle**

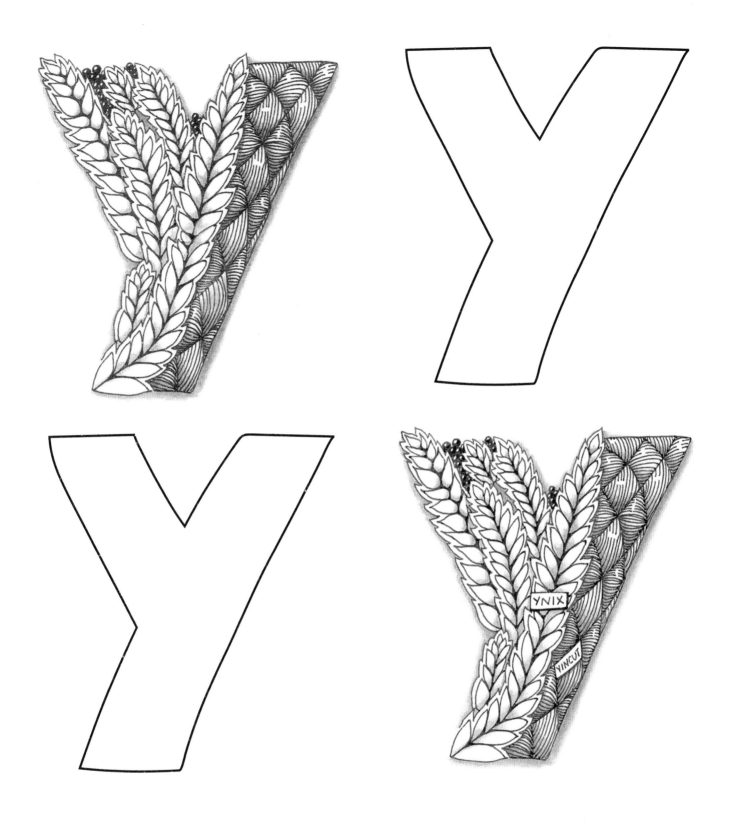

The Letter **Y** from **AlphaTangle**

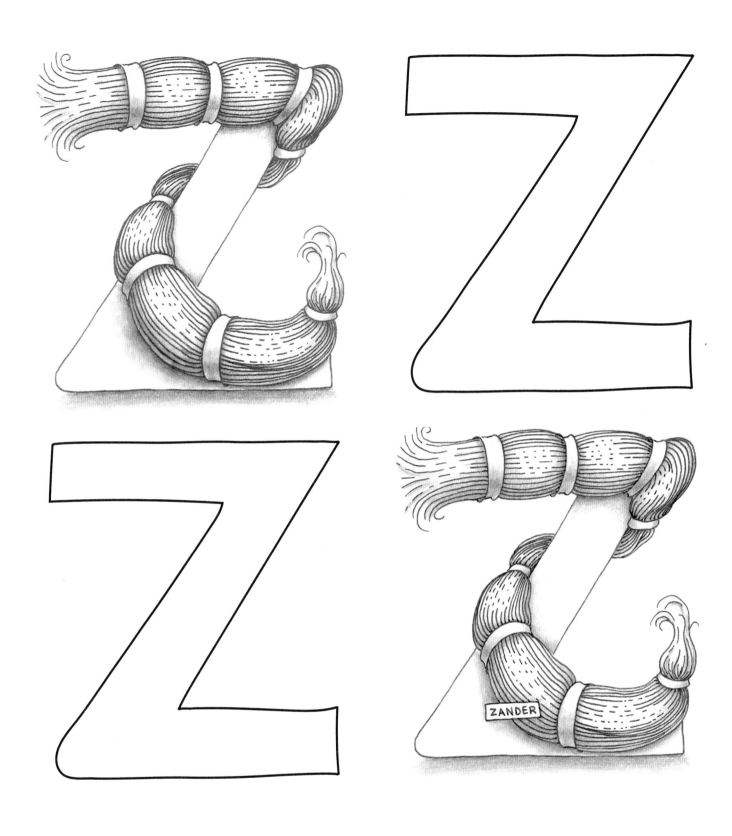

The Letter **Z** from **AlphaTangle**